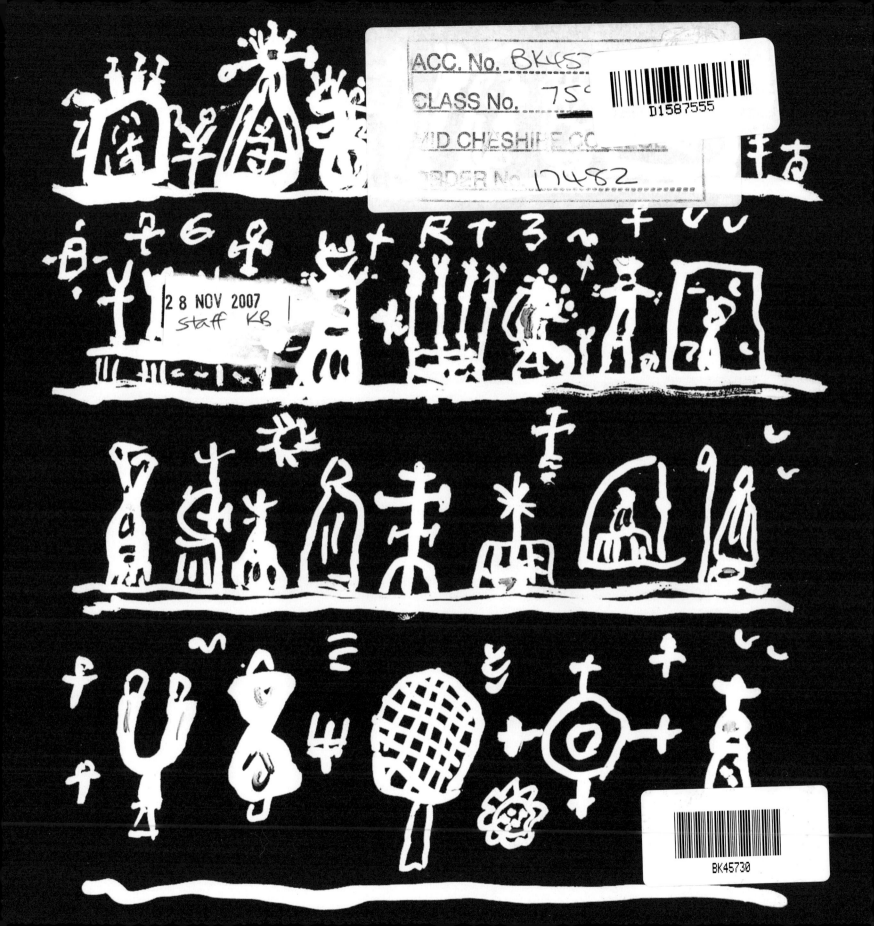

alan davie

JINGLING SPACE

St IVES
TATE

Alan Davie (b1920) is Scotland's greatest living painter, a visionary artist whose work expresses spiritual and cosmic themes and whose career spans more than six decades.

He rose to prominence following his exhibitions in Europe and New York in the mid 1950s, his work is now represented in major collections in the world. He has found inspiration in world cultures such as the Navajo Indians, Aboriginal Australians, the Coptic, Inuit, Carib and Jain traditions.

The exhibition at Tate St Ives highlighted particular periods of this artist's visual journey. The essay by Dr Andrew Patrizio explores the artist's consistent relationship with European surrealism over the past 50 years, revealing new thoughts about this intuitive painter, whose pioneering work is often overlooked as a result of his early association with Abstract Expressionism.

Dr Andrew Patrizio is a curator, writer and lecturer on contemporary art and is Director of Research Development at Edinburgh College of Art.

**Published to accompany
the exhibition at Tate St Ives
25 October 2003 – 25 January 2004**

ISBN 1 85437 526 1

A catalogue record for this publication
is available from the British Library

Library of Congress number 2003111554

Editors Susan Daniel-McElroy, Sara Hughes
Design Groundwork, Skipton
Print + repro Triangle, Leeds

cover
JINGLING SPACE
(detail) 1950
Oil on masonite
© the artist
Collection Scottish National Gallery
of Modern Art

endpapers
JOURNEY OF THE SIGNS
2003
gouache on paper
© the artist

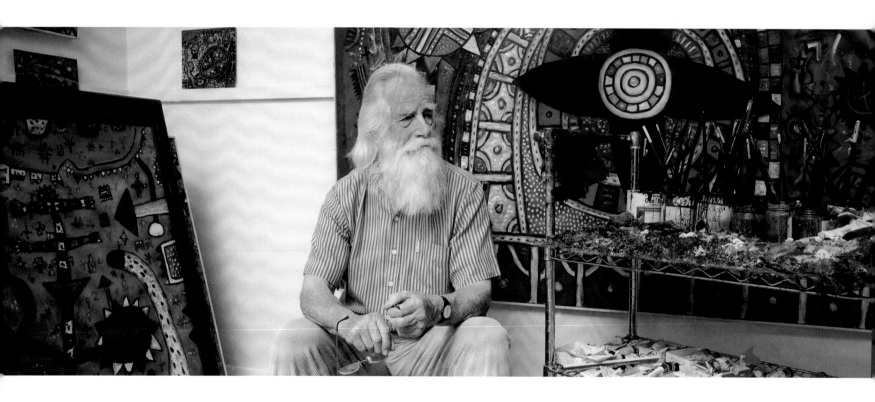

INTRODUCTION

Alan Davie is Scotland's greatest living painter with a career that spans more than six decades. His meteoric rise to international prominence in the 1950s and 1960s was after a number of exhibitions in Europe when his series of monumental paintings attracted the early attention of collectors. Davie was probably one of the first European artists to see and appreciate the zeitgeist of the New York School, meeting de Kooning, Pollock, Motherwell and others in New York in 1956. During his exhibition the same year in New York, his work was purchased by a number of important museums including the Museum of Modern Art in New York. As a result of that early exposure, he is represented in many important collections throughout the world. A visionary and intuitive artist, his painting continues to express spiritual and cosmic themes finding its inspiration in world cultures such as the Navajo Indians, Aboriginal Australians, the Coptic, Inuit, Carib and Jain traditions.

Throughout his career, Alan Davie has also had a long association with Cornwall and the St Ives School of Modernists. Between 1951 and 1974 the Davie family spent almost all their summers in Cornwall when he made works on paper in his Cornish studio. Davie knew most of the second generation St Ives artists; Patrick Heron, Terry Frost and Bryan Wynter and was close to Peter Lanyon (a fellow glider) and Paul Feiler.

Jingling Space at Tate St Ives includes many of Davie's most important works and celebrates his significant contribution to painting, highlighting particular periods of his visual journey. The insightful essay by Dr Andrew Patrizio looks closely at the artist's connection with Europe and Surrealism over the past 50 years, and offers new insight on this important artist whose pioneering work is sometimes overlooked as a result of his early association with Abstract Expressionism. We are indebted to Andrew for his thoughtful text.

We are particularly grateful to individuals and institutions for the loan of key works, and we thank Richard Calvocoressi, The Scottish National Gallery of Modern Art, Edinburgh and Duncan McMillan, Talbot Rice Gallery, University of Edinburgh as well as private collectors. We also wish to acknowledge and thank René Gimpel of Gimpel Fils for kindly supporting the exhibition process and making loans and information available.

As always, numerous individuals within Tate have helped to make this exhibition possible and we are grateful to Mary Bustin, Dave Clarke, Kate Parsons, Rosie Freemantle, Jack Warens and other Tate colleagues too numerous to name.

Finally, we are greatly indebted to Alan Davie for his generous and patient commitment to shaping a major monographic exhibition for Tate St Ives and for ensuring that process was rich and challenging.

Susan Daniel-McElroy
Director Tate St Ives

SLIPSTREAM THROUGH JINGLING SPACE:
THE ART OF ALAN DAVIE

I Alan Davie's career as an artist has been a monument on a European scale to the gift we call the creative imagination. Even the briefest sketch of his career up to the 1960s gives powerful evidence for Davie's meteoric rise, particularly when we take into account that young artists in the 1940s and 1950s were still expected to serve a relatively long apprenticeship before being honoured internationally.

Alan Davie travelled extensively in Europe over 1948–49 and, amongst many formative experiences before major historical and twentieth-century masterpieces, he became the first European painter to see and appreciate the significance of the emerging New York School of artists. This came about through private visits to Peggy Guggenheim's collection in Venice. In 1948, Guggenheim bought a work of Davie's in Venice, and the great collector became an enthusiast and supporter, acting as a conduit for Davie to show his work to acclaim in the United States eight years later. His solo show in New York (1956) put his paintings directly into major museums and collections including that of the Museum of Modern Art New York, and toured the USA.

The list of prestigious venues soon included the Whitechapel in London (1958), when a work was bought by Tate Gallery and *The Times* (6 March, 1958) called him 'an artist who bids to be recognized as the most remarkable British painter to have emerged in recent years.' By 1959 Alan Davie was internationally recognised as a major figure, and large shows followed across Europe, including the Stedelijk Museum, Amsterdam (1962), and the Bern Kunsthalle (1963). In this same year he won the top international painting prize at the São Paulo Bienal in Brazil.

His bibliography is equally formidable, and he enjoyed a major monograph in 1967, edited by the Tate Director of the time, Alan Bowness. And, of course, the major

world collections which now house his work span the globe, from Tel Aviv and New York, to Sydney and Rio de Janeiro.

From these heady beginnings, which also saw him as easily the most revered painter in the art schools of 1960s' Britain, Davie established his rightful place in world art, and in the European and North American canons of art history. Given his passion for world, classical and jazz music, writers have been drawn to analogous discussions of the arts and creativity in general in order to set his work in its true place. These are all proper pursuits, and well documented elsewhere,[1] but not the task at hand here.

This short text is a broad reflection on Davie's work, and the ideas in the text are derived chiefly from looking at the paintings themselves, rather than revisiting the interpretations that have accumulated around them.[2]

II The exhibition is sited in very special place, Tate St Ives, located in an extremity of the British Isles renowned for inspiring artists. Here Davie's large paintings (including 'Creation of Man' (1957), 'Kaleidoscope for a Parrot' (1960), 'Patrick's Delight' (1960), and 'Red Dwarf' (1962)) will face out to the sea – out towards the Atlantic, and within earshot of the waves – offering a fitting reminder of the elemental and perpetually moving quality of his work over the years.

Similarly, there is a common view amongst historians of British painting of the last century that Davie's work has shifted over the decades where each period – the 1950s, the 1960s, and so on up to the most recent work – maps neatly onto certain stylistic progressions. Yet this seems an unhelpful and artificial intervention on what is a glorious arc of a career that sweeps across most of the twentieth century and continues to this day. Davie's work has an energy and sensibility that seems to reside more in his own individuality as a painter and man. Therefore the work of the 1950s and 1960s is far closer to the more recent work – with its proscenium settings and kaleidoscopic turnings – than conventional categorisation may suggest. Standing

1. The primary accounts being Alan Bowness (ed), *Alan Davie*, London: Lund Humphries, 1967; Michael Tucker and Douglas Hall, *Alan Davie*, London: Lund Humphries, 1992; Patrick Elliott, *Alan Davie. Work in the Scottish National Gallery of Modern Art*, Edinburgh: National Galleries of Scotland, 2000

2. This text was begun following an extended visit to the Alan Davie display at the Scottish National Gallery of Modern Art. Accompanied by Bill Hare, many of the ideas here were sparked off by this initial dialogue, which I acknowledge here

3. Quoted by André Breton in 'What is Surrealism?', 1934, in Herschel B Chipp, *Theories of Modern Art. A Source Book by Artists and Critics*, Berkeley: University of California Press, 1968, p416

4. Quoted by Michael Tucker, 'A company beyond time. Alan Davie at the Cobra Museum for Modern Art', in *Alan Davie Schilderijen Paintings, 1950–2000*, Amstelveen, The Cobra Museum for Modern Art', 1989, p13

5. 'I confess', in *Visione Colore*, Palazzo Grassi, Venice, 1963 and see the 'Artist's Statement', written in 1962 after his first aerobatics in a glider, in Tucker and Hall, op cit, p56

close to Davie's greatest works, with all their vitality and imagination intact, one realises the paucity of art historical categorisation and its weakness in truly explaining anything of importance.

III 'I say that one must be a *seer*, one must make oneself a seer.'
Arthur Rimbaud [3]

Davie views his activity as a painter as 'fundamentally the same as artists of remote times... engaged in a shamanistic conjuring up of visions which will link us metaphorically with mysterious and spiritual forces normally beyond our apprehension.' [4] The way such access to the visionary finds expression for Davie – in making himself a seer, in Rimbaud's sense – is, of course, still distinct from artists of earlier periods, and technology has played a part in the difference. Davie has often expressed his love of gliding, following his first flight in 1960 – 'I discovered that I could be a bird (I had always longed to be able to soar like the seagulls) and now I can fly amongst my clouds, and swoop and climb and circle in my big white sailplane.' [5] – but this enthusiasm is more important than a mere diversion from his profession. In fact at a deeper level it has messages about artistry, technique, and free association, working in proximity to control. Gliding, as Davie has suggested, is entirely different from powered flight, where there is an instrumental and even violent connection between getting somewhere and using the fastest means available. Gliding is a responsive technology which must be employed to best effect in order to anticipate and move with the dynamic movement of the air; shifting currents are beyond one's control and potentially dangerous. It would overstate the case to say this was natural flying, as gliding is an artificial intervention in the sky just like powered flight, but it involves the pilot accepting a large degree of collaboration with powerful elemental forces. Unlike under the power of a jet engine, 'getting somewhere' only occurs on a psychological level. André Breton, in *Surrealism and Painting* (1928) wrote: 'The marvels of the earth a hundred feet high, the marvels of the sea a hundred feet deep, have for their witness only the wild eye that when in

need of colours refers simply to the rainbow.'[6] No doubt Davie felt himself, in a glider, to be an agency for external forces through the act of letting go.

In this context, Carl Jung, acknowledged as a major figure for Davie, has written very beautifully about the limits of our understanding and our perceptions and how the world of symbolism is a response by humans to such limits. 'As the mind explores the symbol, it is led to ideas that lie beyond the grasp of reason… Man, as we realise if we reflect for a moment, never perceives anything fully or comprehends anything completely. He can see, hear, touch, and taste; but how far he sees, how well he hears, what his touch tells him, and what he tastes depend upon the number and quality of his senses. These limit his perception of the world around him. By using scientific instruments he can partly compensate for the deficiencies of his senses… But the most elaborate apparatus cannot do more than bring distant or small objects within range of his eyes, or make faint sounds audible. No matter what instruments he uses, at some point he reaches the edge of certainty beyond which conscious knowledge cannot pass.'[7] Gliding, and for that matter scuba diving too, has brought the 'edge of certainty' a little nearer Davie's perception but, as Jung recognised, beyond that we require the symbolic. As the artist has stated: 'You can't make a mark without it taking on some kind of significance, some kind of symbolic quality.'[8]

IV We live in a world that is slowly tying itself in knots of self-consciousness and the ideas around free association, the loosening of control and freeing the unconscious are currently unfashionable notions. This is likely to change. Free will is concerned with the attempt to find a language beyond culture and convention, which does not consider refinement essential. The agent of free will seeks to shed pre-programmed and acquired knowledge. Over the generation preceding Davie's emergence, a powerful group of individuals around Surrealism tested the boundaries of freedom, psychologically and artistically. Breton gives us a definition of Surrealism in 1934 which offers one template for Davie's approach: 'Surrealism: Pure psychic automatism, by which it is intended to express, verbally, in writing, or

6. In Chipp, op cit, p402
7. Carl G Jung, 'Approaching the Unconscious', in *Man and his Symbols*, Arkana / Penguin, 1990, p21
8. Andrew Patrizio and Bill Hare, 'An interview with the artist', in *Alan Davie. Works on Paper*, Edinburgh: Talbot Rice Gallery / London: British Council, 1992, p37

9. In Chipp, op cit, p412
10. From an unpublished transcript of an interview between the artist and Susan Daniel-McElroy, Director of Tate St Ives, 24 June, 2003
11. Quoted in Barry Green, *The Mastery of Music. Ten Pathways to True Artistry*, London: Macmillan, 2003, p254
12. Jean Arp, 'Abstract Art, Concrete Art', c1942, in Chipp, p391

by other means, the real process of thought. Thought's dictation, in the absence of all control exercised by the reason and outside all aesthetic and moral preoccupations.' [9] Two thoughts strike one in this text; firstly the idea that this is more real than perceived reality, and that therefore Davie paints in a sense 'real' rather than 'fantasy' worlds. Secondly, that if this is 'thought dictated' then one needs a dynamic calligraphy and language to captures its profound nature, and surely if anything, Davie has done this. He has clearly contributed to the tradition of Surrealism, particularly in his intention to divest himself of limiting conventions, of combining eclectic and metaphorical imagery that creates a visual world beyond the real, and by refusing facile shortcuts in the way he makes his work. He has recently reasserted the debt: '… we felt by freeing ourselves from self-conscious thinking one could liberate sub-conscious ideas much in the way the Surrealists did.' [10] But rather than being about abandonment and chaos, his painting negotiates freedom with control, vitality with discipline, depth with surface, the personal with the egoless. He works in the spirit of Stravinsky, who in the *Poetics of Music* (1974) stated that 'composition is selective improvisation,' [11] – final meaning emerging through initial meaninglessness. We find proof in the paintings of all stages, which far from being arch experiments with chaos are ultimately distinctive, authorial, and particular, made by the working body of the artist. They breathe as bodies breathe, which is why we should never underestimate the physical power of a Davie painting. (This was captured most vividly by a film which Bili Davie, the artist's wife, made in 1961 – here we saw the true extent of Davie's exertion around enormous masonite boards.) Jean Arp (whose paintings Davie saw first hand in 1948 in Zürich and who quite possibly inspired the surrealistic tendency of Davie's titling of works) said of automatic poetry that it 'comes straight out of the poet's bowels or out of any other of his organs that has accumulated reserves… His poems are like nature: they stink, laugh and rhyme like nature.' [12] Whilst Davie's work clearly has inspiration in the world of the spirit and atavism, they remain paintings from the hand and the mind, from a body gliding somewhat above the earth's surface, but a body nonetheless.

The photographs of Davie painting in his studio have, I believe, been under-appreciated, for example those in 1960 taken by Alan Foreman and in particular a series published in the late 1960s and early 1970s ('Flying Machine', 1968, among others are in the background). These photographs, and their repeated use in catalogues of Davie's exhibitions over the years, speak of physical movement in and around the canvas, the incredibly lithe and muscular body of the artist, and the dance with the medium. We connect with the paintings through imaginative projection of how they were made, by recreating at some level the movements and gestures that resulted in paint being applied to canvas. But the photographs are only evidence of how the works were made and Davie himself insisted that 'there is no question of the picture expressing the activity of its production.' [13] What the photographs do not show is how space and time are brought together in this way of working. Painting creates spatial ambiguity (one thinks of the 1970s works above all) and compresses time.

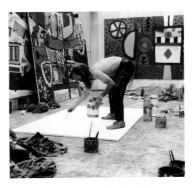

Alan Davie, Gamels Studio, 1965.
Daniel Frasnay

There are both immediate and broad reasons why the work is not 'abstract' in any meaningful sense. The psychic power of images – recognised by Jung and the reason why Davie has never abandoned figuration – means we are compelled to make and recreate them anew, over millennia and across cultures. And whilst certainly abstraction is a language which visits or passes through Davie's work, and through that passage gives it strength, to be fully abstract the paintings would have to aspire to the absolute, the utopian and the universal. Beneath these expansive notions lies the idea of perfection, an uncomfortable concept for Davie. 'It's in the back of a human being's mind that life is perfect; if only we could cure all ills, live forever, everything would be wonderful. Perfection is a myth which is unnatural to human beings.' [14] The indexical motif of footprints and hands that Davie has often 'left' on the surface of some canvases establishes the corporeal nature of what we are viewing; this has not been delivered from a universal, anonymous force. The artist has moved across the canvas, either on the floor or, since the 1970s, on the easel, registering simultaneously the world of gravity, density, mass, space, movement and colour. These languages are often employed by abstraction –

13. Notes by the Artist, Whitechapel Art Gallery, 1958
14. Interview with Susan Daniel-McElroy, op cit

15. 'Joan Miró, from an interview with Georges Duthuit', 1936, in Chipp, op cit, p431
16. Andrew Patrizio and Bill Hare, op cit, p34
17. Interview with Susan Daniel-McElroy, op cit

qualities in painting that appeal directly to the eye or to a more intellectualised notion of the sublime and absolute. However, it is quite clear that Davie's work has never left the world of signs, symbols, references to dance, ritual, poetry, music, sometimes even elliptical narrative, to speak to us in a language we understand or more accurately from which we are able to make meaning. Davie is more in harmony with the passionate sense with which Joan Miró described his art: 'Painting or poetry is made as we make love; a total embrace, prudence thrown to the wind, nothing held back... Have you ever heard of greater nonsense than the aims of the Abstractionist group?' [15] The pleasant paradox of Davie's work is that it seems to be a vortex for the world, with all its variety of meanings, cultures and rhythms, whilst always being 'Alan Davie paintings', distinctive and attributable.

V Davie's work aspires to the elemental, to communicate directly the elemental in art, but not to make a work which illustrates the elemental. It tries to be the destination, not the signpost. His work is particularly exciting in this unity between doing and meaning – 'The idea comes out of working.' [16] He does not make works where one can easily draw the co-ordinates between what he meant in each work and how we might then understand the work. For Davie, the act of painting, at the highest level, is the meaning. In fact, we can go so far as to say that he does not paint for an audience, for to do so would patronise his viewers and limit the furthest most horizon of his vision. To enlighten an audience, if art aspires to do such a thing, is not to pass on knowledge, either accessible or obscure, but to create a space for our own self-development – so the painter takes responsibility for making the finest paintings he can, and we take responsibility for finding our own meaning and testing ourselves in front of the work. Davie puts it thus: 'if one looks at a painting with an open mind, one can experience the same things as the artist has done... You're discovering a revelation of something which one had all the time but which didn't know about.' [17] For us, the act of looking is the highest response we can make, whether or not we know about the artist's intentions – in a way it is about that intriguing connection between the 'written' and the 'read'. Consequently, the

term 'interrogative text' [18] might be used here, in the sense that rather than passing over information or knowledge, or dictating a message to us, Davie's paintings make themselves available to us to construct our own meanings and examine our own inner lives, to enliven and enrich.

VI Particularly in the early decades, but still to this day, Davie seems close to the emergent and embryonic, articulated through the circling space where ideas are formed, born, and grow – a 'jingling space' to borrow the title of a great painting of 1950, and one which gives the title of the Tate St Ives exhibition. This painting evokes a space where living forms and sounds might emerge from the dark; a place ultimately of illumination and potentiality.

Scanning the surfaces of his works, over all periods, we witness how passages move between the calligraphed line, the encircled form, the dribbled accidents, the open play of colour, legible writings and scripts, known signs and symbols. The transition and juxtaposition between these visual languages is not done in the spirit of quotation and objectivity; he is not illustrating the varieties of expressive languages we have at our disposal, as this would border on intellectualised deconstruction. Rather he is gliding over the psychic and cultural expressions which he knows of and intuits, as they grow around him. In this, a major precedent would be Pablo Picasso's 'Les Demoiselles d'Avignon' (1907), with its passages across cultures and visual languages, in the moment of their formation. Chaos threatens but never takes hold. One way to characterise this manner is as a dance between strangers, which implies an active, physical engagement with 'the other' – certainly not to be mistaken as becoming something he is not, nor dispassionately quoting exotic references for no purpose. Instead, a temporary but heartfelt dialogue in dance is begun, for the duration of a painting, or a particular part of a painting. When the dance has stopped, the painting exists. Despite the challenges and torments that accompany the vocation of the painter, this is undeniably a privilege for the artist, and for us to witness.

18. I borrow the term from Catharine Belsey's *Critical Practice*, London: Routledge, 1980, p90–92

19. In *Alan Davie Schilderijen
 Paintings, 1950–2000*, p5
20. In David Sylvester, *Interviews
 with Francis Bacon. 1962–1979*,
 London: Thames & Hudson,
 1980, p83

Painting becomes embryonic writing in multiple languages, with no one language privileged above the other. Different possibilities and ends are entertained within works and across series, depending on the unconscious will of the artist as agent for these intentions. Whilst the paintings of the 1950s and 1960s explore the idea of multiple possibilities through the very act of painting, it is no less a feature of the transition to the poetic stage plays of the 1970s, such as 'The Studio #28' (1975) or 'Dancer Myth #6' (1976), where the scenes are set more precisely and the symbols conscripted more distinctly into play. Yet still the possibilities of narrative and resolution are held just beyond reach. The manner of delivery has altered slightly, without the message being any less elusive and intriguing. In fact the move from the explicitly energetic work of the 1960s to the still enigmatic dramas of the 1970s and beyond is less marked than we might believe. Spontaneously created drawings and works on paper often drove the imagery of the latter and represented a response to the perceived 'wastage' of strong ideas that disappeared under the constantly over-painted canvasses of the 1960s. (Quite properly, a number of these works on paper are included in this exhibition.) In all cases, the language of art was arrived at through play (and Davie's work often signals the importance of childhood and lightness, over intellectualism and rigidity) beyond which the aspiration of art is to achieve transformation and growth.

VII 'my own creations are a source of wonder also to me.' [19]

Davie's is an art of positive assertion and celebration, and not an art of questioning, of taking apart or even of assemblage/collage. In terms of modern art in the twentieth century the least attractive innovation to Davie seems to be 'the cut' – collage, the violence of the spliced image. The use of the knife or blade to make imagery seems entirely absent. This is in keeping with my theme of the oceanic and of the artificiality of sharp boundaries; cutting the picture surface is like separating out oceans. He is the opposite of an artist like Francis Bacon – no negative existentialism, violence, or 'exhilarated despair' as Bacon called it. [20] Davie is a man happy

in his own body; Bacon was decidedly not. Interestingly, in a little-known catalogue text by David Lewis in 1958 (notably *before* his joyous paintings of the 1960s), Davie's distinctive positivism was remarked upon: 'Those of us who, in the twentieth century world of anguish, would reject as negative an attitude which so lacks in construction, must recognise in Davie at least a barometer-man who has the courage to endure intensely, in acceptance and without condemnation, the extreme antipodes of living to which his honesty carries him, and yet to find wonder there.'[21] Reflection and self-searching for Davie always has the end of positive assertion, rather than introspective negation. Interestingly, Roland Penrose noted in 1964 that Bacon and Davie 'have had a wide influence on the younger generation... however, widely different in their methods and achievements.' In an exchange on the subject of will and freedom between Bacon and David Sylvester, we see the dramatically different treatments of similar concerns across the two artists:

FB: I think with great effort I'm making myself freer. I mean, you either have to do it through drugs or drink.
DS: Or extreme tiredness?
FB: Extreme tiredness? Possibly. Or will.
DS: The will to lose one's will.
FB: Absolutely. The will to make oneself completely free. Will is the wrong word, because in the end you could call it despair. Because it really comes out of an absolute feeling of it's impossible to do these things, so I might as well do anything.'[22]

How differently Bacon and Davie approach freedom, will and the ability to make art.

By the mid-1950s Davie understood the importance of letting the air currents of creativity be his guide, rather than trying to force his creative will on his art. 'The more obstinately one tries to learn how to shoot for the sake of hitting the target, the less one will succeed. In the same way, as long as I am aware of my inability to paint

21. David Lewis, 'Introduction', *Alan Davie in retrospect*, Wakefield City Art Gallery, 1958, unpaginated
22. Sylvester, op cit, p13

23. Alan Davie, from a lecture 'The Creative Act and Zen Buddhism', Institute for Contemporary Arts, London, 1956, quoted in Robert Melville, 'Alan Davie', *Motif 7*, summer 1971

exactly as I desire, I am paralysed by the very desire and only when I succeed in abolishing completely that desire can I create anything.' [23]

VIII One might respect the views of those who reserve judgement and whose training has told them to contextualise and deconstruct the work of artists from Western culture who make reference to world cultures, as Davie has with the art of Navajo Indians, Aboriginal Australians, the Coptic, Inuit, Carib and Jain traditions, to name a few. They are uneasy about the act of appropriation from the margins and of adopting of visual grammars not one's own. Yet one immediate response is that no language – whether written or graphic – is pure. For example, re-inscribing the Spanish texts and Catholic-inflected iconography of South American Indians, as Davie has done in paintings of the 1980s, registers, in passing, the colonialist exploits of the Spanish in the 16th and 17th centuries that imposed another cultural influence on that continent. The crime occurred through the driving forces of economic ambition and imperialism; the work of artists of the stature of Alan Davie can contribute to atonement and new dialogues that may in turn avoid repetition of the abuse of power between cultures.

Davie's work is not often discussed in this way, but it can undoubtedly be appreciated through the prism of new ways of thinking. Davie's paintings have survived at the summit of European art for nearly 60 years because they have kept their vitality over that time. Strictly speaking, perhaps no art can be timeless, given cultural and perceptual shifts on the macroscopic level, but Davie's art approaches timelessness like few others in the canon of Western art.

Andrew Patrizio

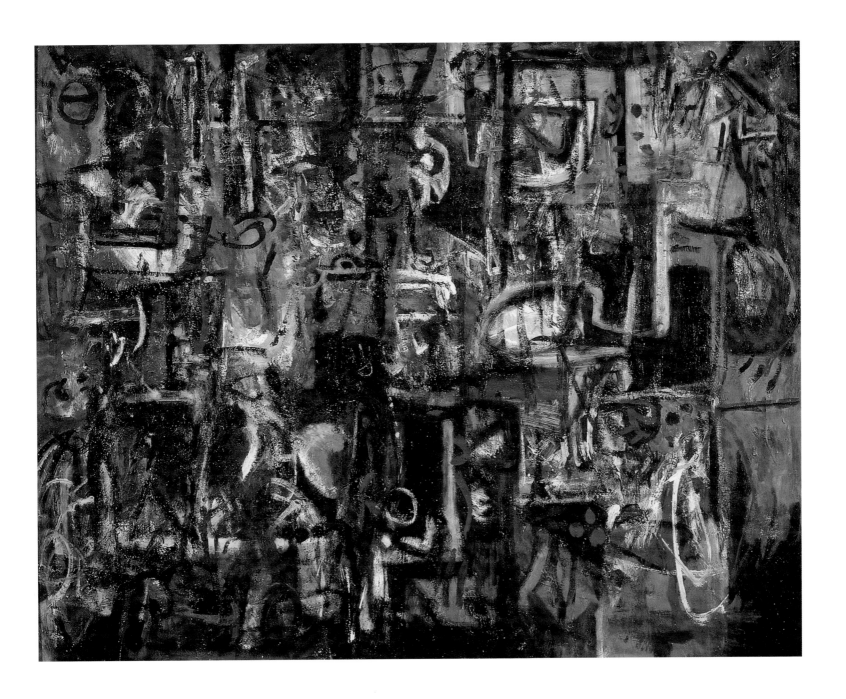

previous
JINGLING SPACE
1950
oil on masonite
122 × 152.5 cm
© the artist
Collection Scottish
National Gallery of
Modern Art

right
PAGAN DANCE II
1948
133 × 99 cm
oil on masonite
© the artist

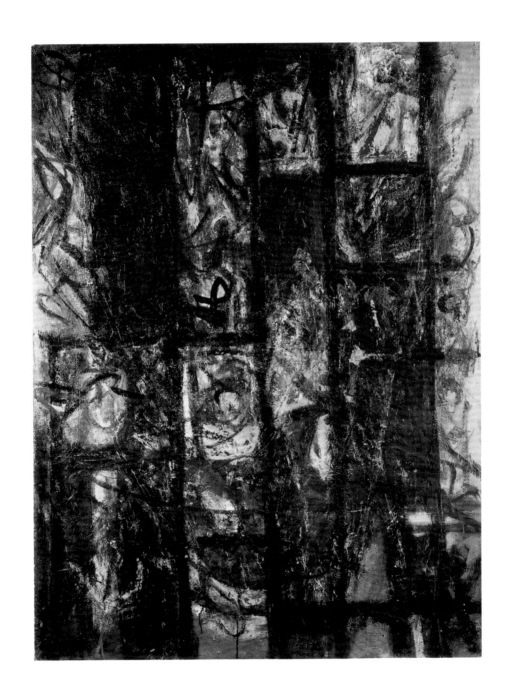

CREATION OF MAN
1957
triptych 213.5 × 366 cm
oil on masonite
© the artist
Private collection

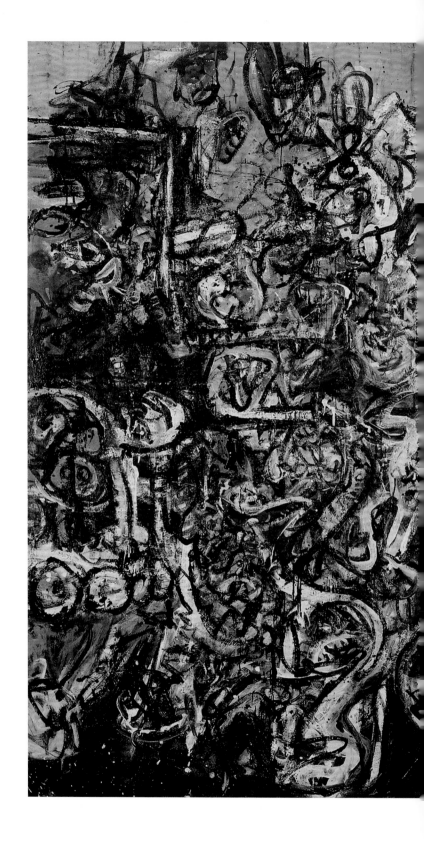

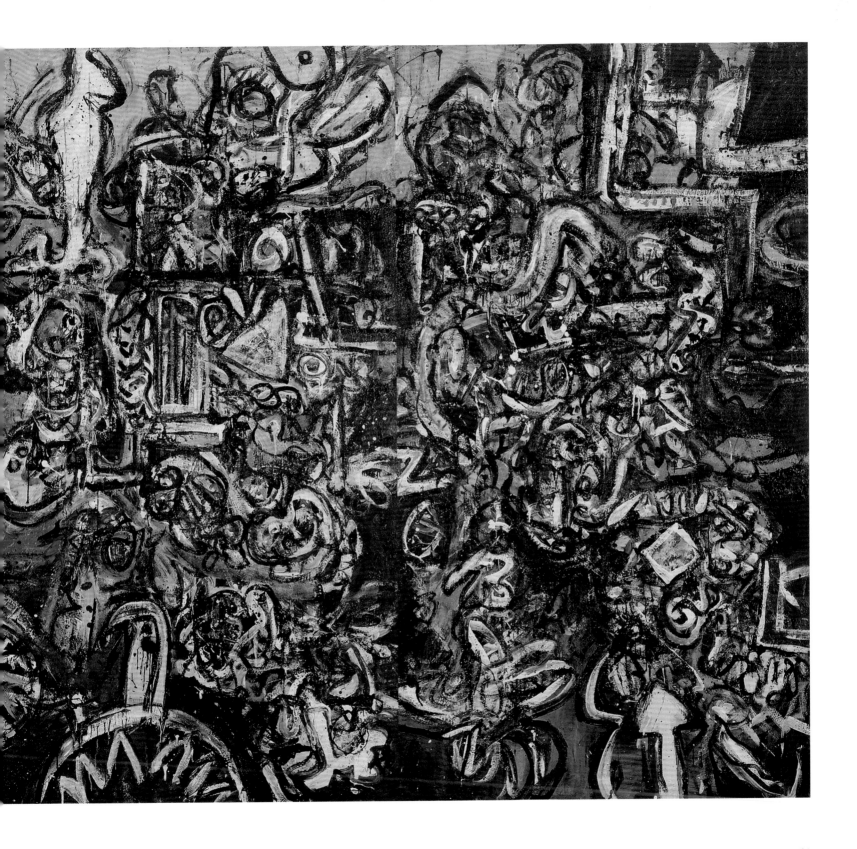

THE RED DWARF
1962
oil on canvas
triptych 213.5 × 366 cm
© the artist
Collection Scottish
National Gallery of
Modern Art

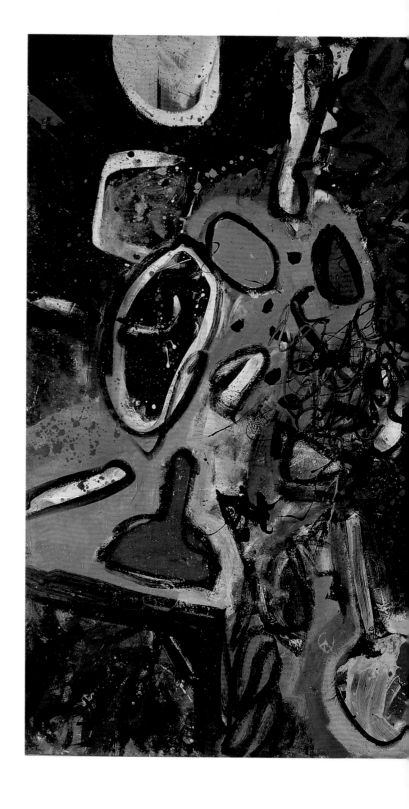

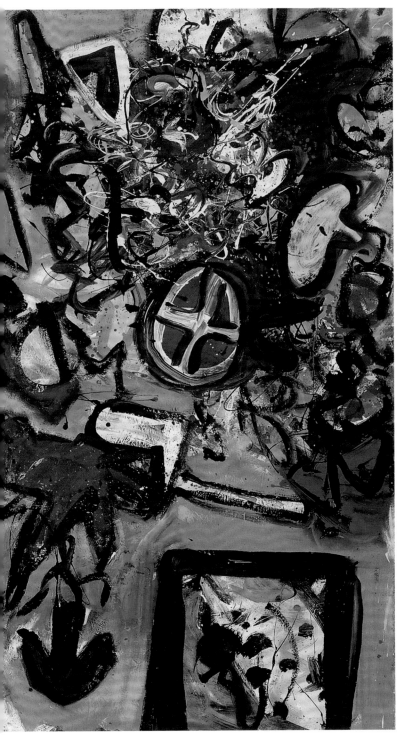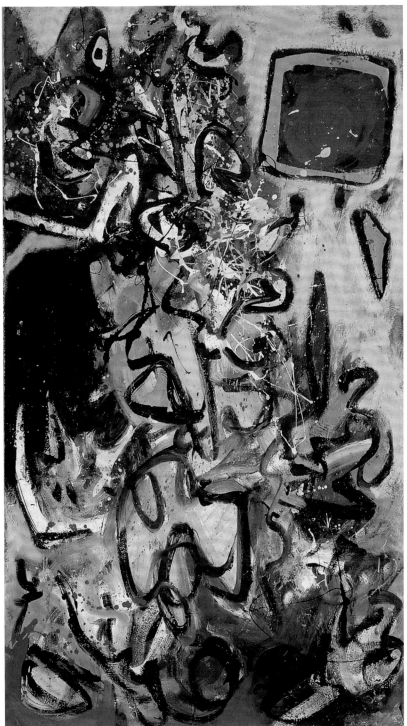

HOLYMAN'S BIRD MEDITATION
1960
152.5 × 122 cm
oil on masonite
© the artist

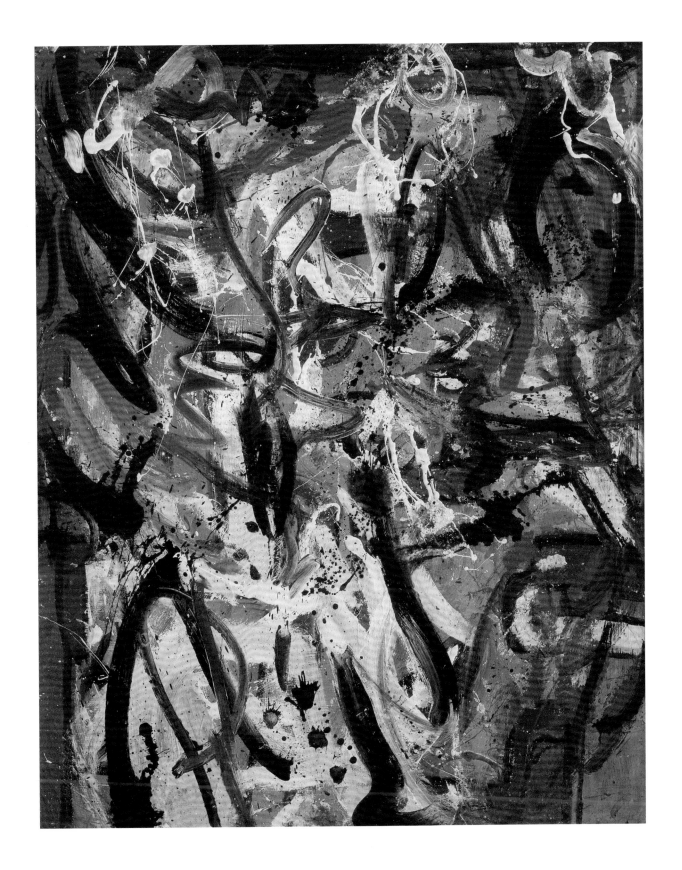

THE DISINTEGRATED TARGET
1960
214 × 172.7 cm
oil on canvas
© the artist
Collection of the artist

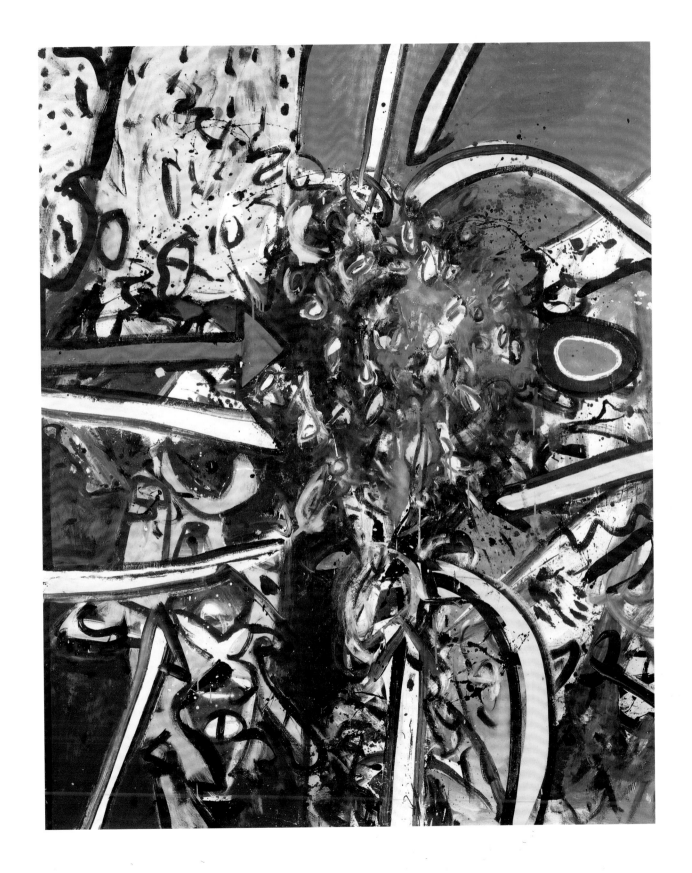

LUSH LIFE
1961
oil on canvas
213.4 × 172.7 cm
© the artist
Collection Scottish
National Gallery of
Modern Art

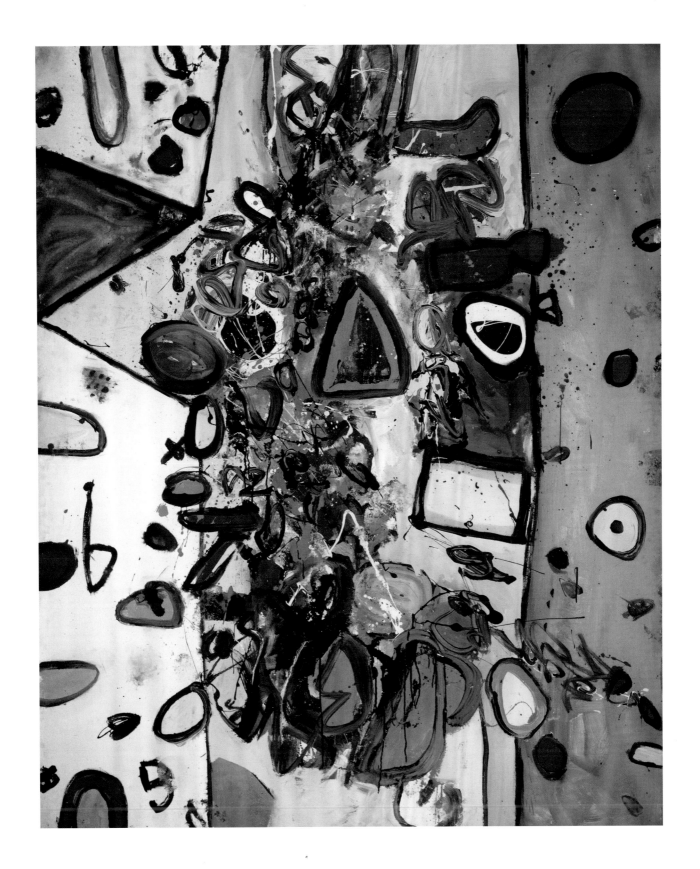

KALEIDOSCOPE FOR A PARROT
1960
oil on canvas
triptych 213.4 × 366.4 cm
© the artist
Collection Talbot Rice Gallery,
University of Edinburgh

PATRICK'S DELIGHT
1960
triptych 213 × 366 cm
oil on canvas
© the artist
Collection Claire and
James Hyman, London

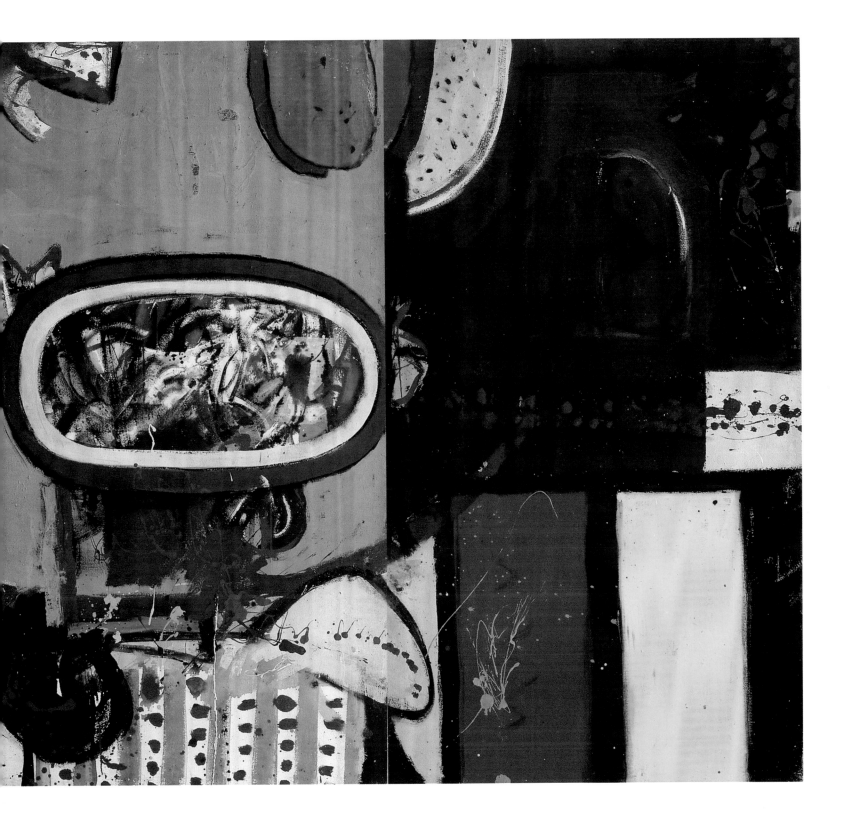

THE STUDIO NO. 28
1975
oil on canvas
152.3 × 183 cm
© the artist
Collection Scottish
National Gallery of
Modern Art

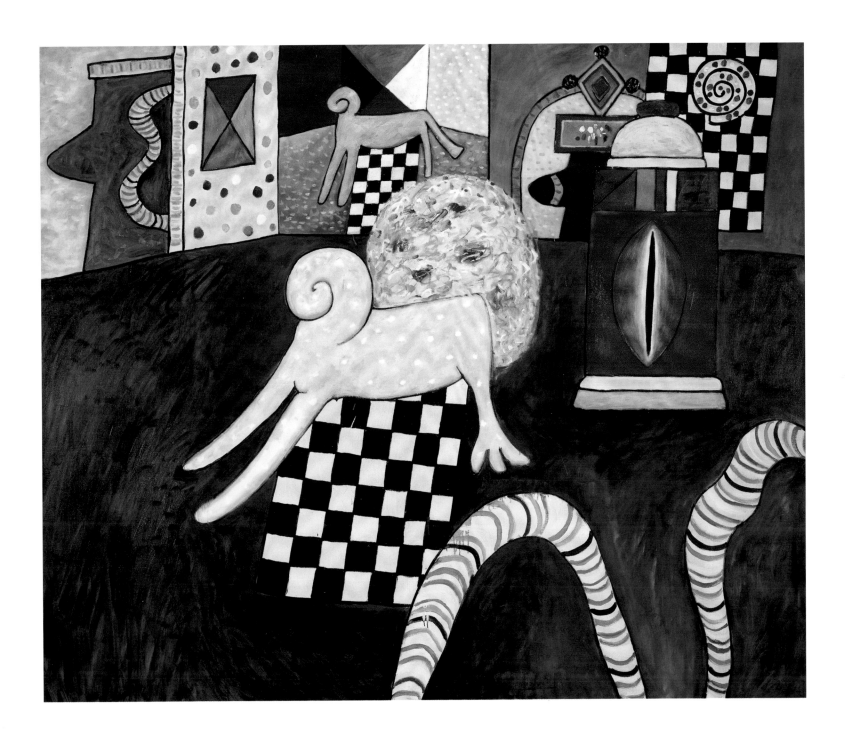

FLIGHT OF THE FLEEBLIES NO. 4
1973
oil on canvas
76.2 × 101.6 cm
© the artist
Courtesy Gimpel Fils

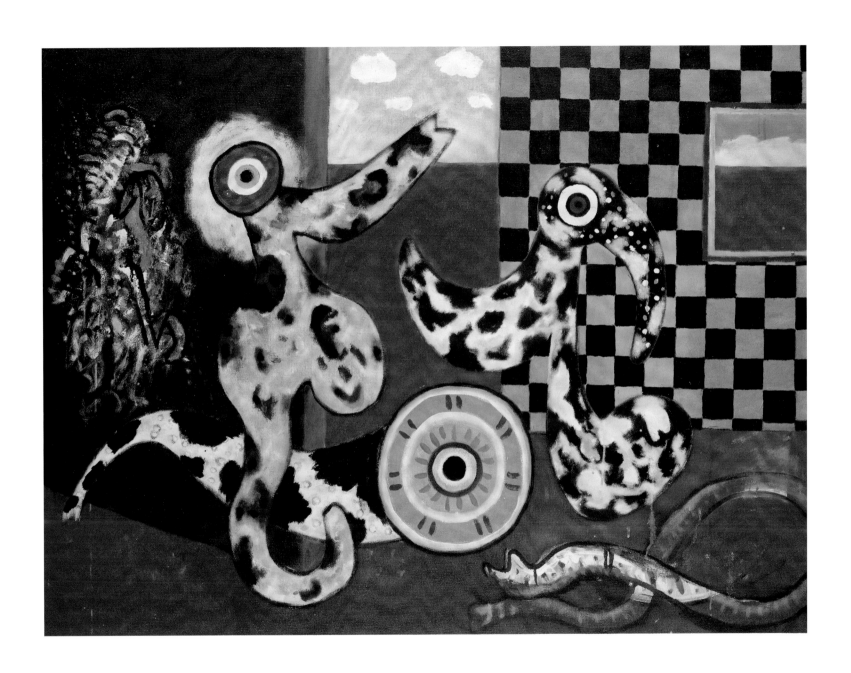

DANCER MYTH NO. 6
1977
oil on canvas
diptych 213.5 × 244 cm
© the artist
Collection Scottish
National Gallery of
Modern Art

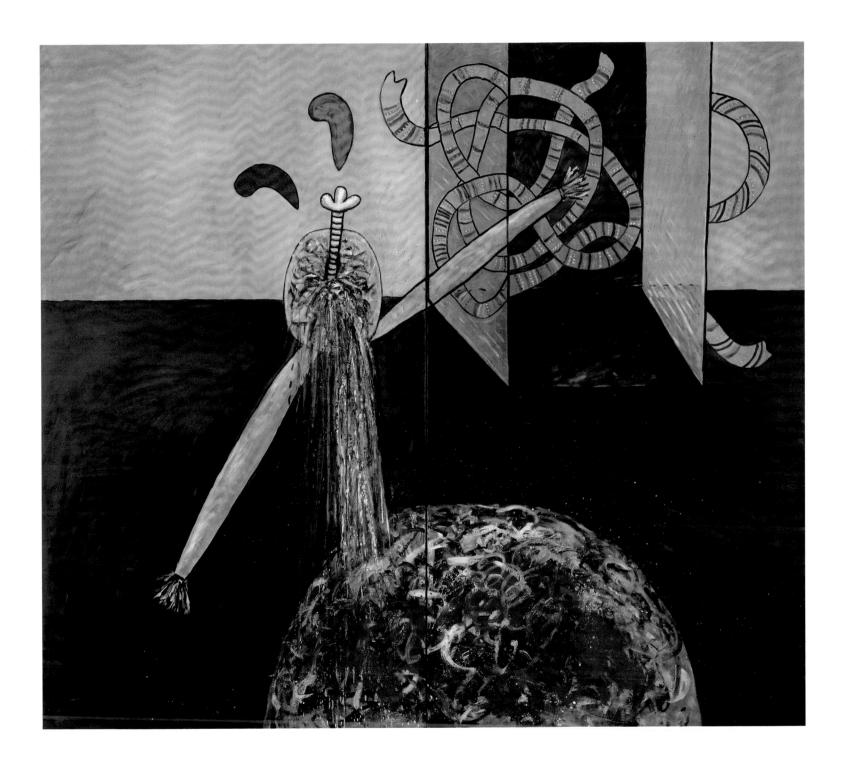

FAIRY TREE NO.5
1971
oil on canvas
172.7 × 213.4 cm
© the artist
Tate

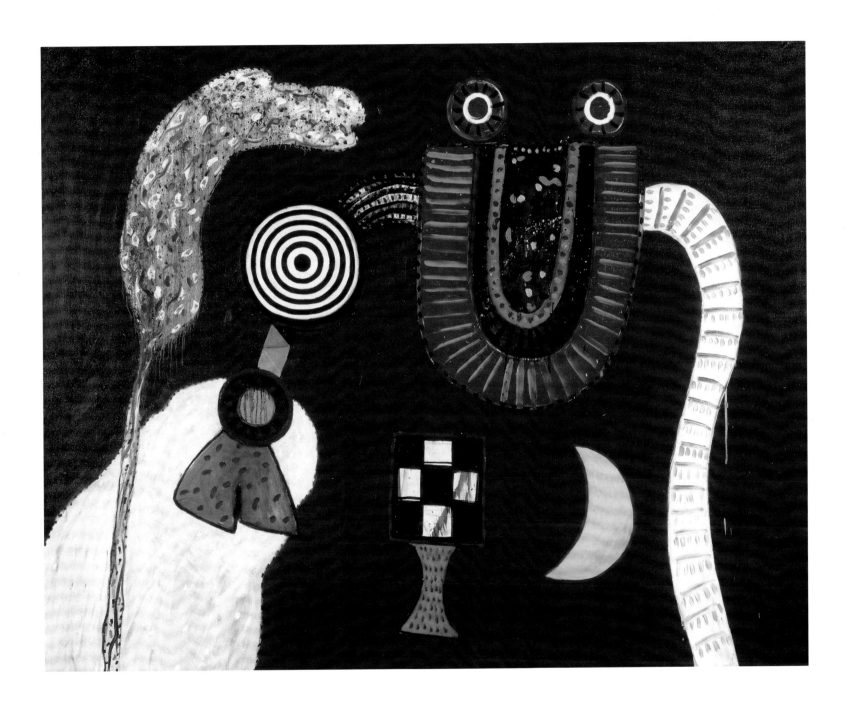

COSMIC SIGNALS NO. 7
2002
oil on canvas
156.5 × 187.2 cm
© the artist

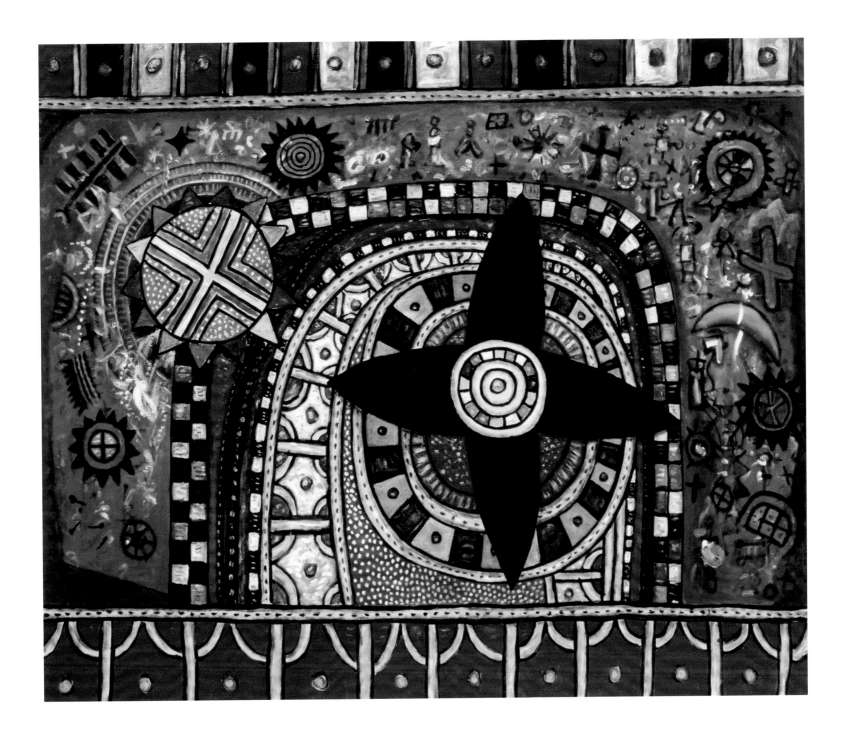

BIRD FOR RT
2003
gouache on paper
© the artist

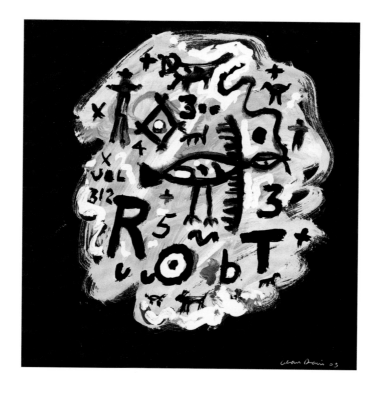

CAT'S VISION
2003
gouache on paper
© the artist

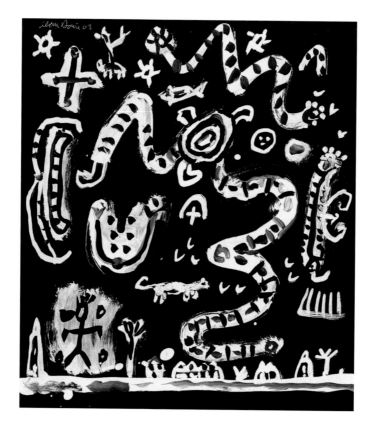

44

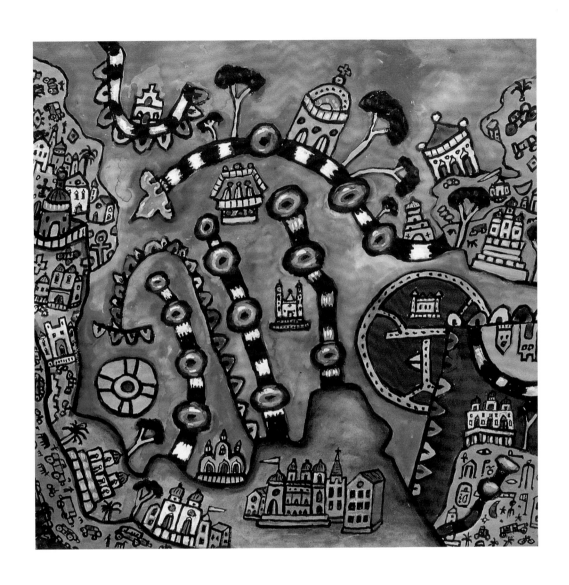

ISLAND MAPS NO. 14
1998
gouache on paper
56 × 56 cm
© the artist

ALAN DAVIE

CBE HRSA RWA
DA EDIN (EDIN) Hon D. Litt

Alan Davie's glider and Jaguar E-type,
Cambridge University Gliding Club, 1966.
David Ware

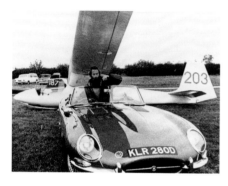

Alan Davie, Gamels Studio, 1965.
Daniel Frasnay

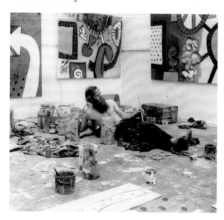

Biographical summary

1920	Born Grangemouth Scotland
1937	Edinburgh College of Art
1941–6	War Service, Royal Artillery
1946–7	Professional Jazz Musician Married Janet 'Bili' Gaul
1948–9	Visits the Venice Biennale and then travels Europe with exhibitions *Alan Davie* Galleria Sandri in Venice and *Alan Davie* Galleria Michelangelo in Florence Paintings bought by Peggy Guggenheim whom he meets.
1949	Making jewellery and silverware Birth of daughter Jane
1950	First solo show at Gimpel Fils Gallery, London continuing to exhibit biennially to date Purchases cottage near Lands End, Cornwall which he continues to visit in summer months
1956	First American Show, Catherine Viviano Gallery, New York Subsequently shown frequently throughout the USA
1956	Gregory fellowship, University of Leeds, Public Lectures
1958	*Alan Davie Retrospective*: Wakefield Art Gallery *Alan Davie Retrospective*: Whitechapel Art Gallery, London *Alan Davie Retrospective*: Walker Art Gallery, Liverpool
1959	Teaching: Central School of Arts and Crafts, London
1960–80	Gliding: 2000 hours soaring in England, Switzerland, USA
1961	Exhibits at galleries in Milan, Paris, New York, Pittsburgh, Los Angeles
1962	*Alan Davie* solo show: Stedlijk Museum in Amsterdam
	Alan Davie solo show: Kunstnernes Hus, Oslo *Alan Davie* solo show: Kunsthalle in Baden-Baden, Germany, *Alan Davie* solo show: Kunstgewerbeverein, Pforzheim *Alan Davie* solo show: Kunsthalle Berne, Switzerland
1963	*7th Bienal Di São Paulo*, Brazil – Painting Prize winner from where the British Council exhibition of 17 paintings travelled to Rio de Janeiro, Buenos Aires, Santiago, Lima and Caracas
1963–70	Experiments in Lithography
1965	Exhibits in New York, Cologne, Copenhagen, Stockholm, Oslo *Alan Davie* at Graves Art Gallery, Sheffield
1966	Exhibits at Castle Museum, Norwich and Rotterdamsche Kunstkring, Rotterdam
1967	University of Minnesota, Arts Club exhibition
1968	Exhibitions in Hannover, Düsseldorf and Lübeck
1970	*Alan Davie Retrospective:* University of Texas, USA *Alan Davie Retrospective:* Musée D'Art Contemporain, Montreal
1971–79	Concerts and recordings of spontaneous music
1972	Awarded CBE (Commander of the British Empire)
1975–91	Spends winter months in St Lucia painting gouaches
1977	Lecturer at Royal College of Art, London
1979	Visit to Australia and Bali
1982	*Alan Davie Retrospective:* Hong Kong Arts Centre, Hong Kong

1991 Senior Fellow, Royal College of Art, London	Canada Musée D'Art Contemporain, Montreal National Gallery of Canada, Ottowa	United Kingdom Arts Council of England British Council

1991 Senior Fellow, Royal College of
 Art, London
1992 *Retrospective*: McLellan Gallery,
 Glasgow
 Alan Davie, Works on Paper: Talbot
 Rice Gallery, Edinburgh
1992–95 *Alan Davie, Works on Paper:* British
 Council Touring Exhibition: South
 America, Australia, North Wales
 and Vienna
1993 *Retrospective*: Barbican Gallery,
 London
1997 *Alan Davie Drawings*: University of
 Brighton
 Alan Davie: Scottish National
 Gallery of Modern Art, Edinburgh
2000 *Alan Davie Retrospective*: Scottish
 National Gallery of Modern Art,
 Edinburgh 2001 *Alan Davie
 Retrospective*: Cobra Museum,
 Amsterdam
2003 *Jingling Space* Tate St Ives
 and exhibitions at
 Gimpel Fils Gallery, London
 James Hyman Fine Art, London
 Nothelfer Gallery, Berlin

**Work in International
Public Collections**

Australia
Art Gallery of South Australia, Adelaide
Art Gallery of New South Wales, Sydney

Austria
Museum Des 20 Jahrhunderts, Vienna

Brazil
Museum of Modern Art, Rio de Janeiro
Museo De Arte Contemporânea, Sâo Paulo

Canada
Musée D'Art Contemporain, Montreal
National Gallery of Canada, Ottowa

France
Foundation Maeght, St Paul

Germany
Staatliche Kunsthalle, Baden-Baden
Städtliche Kunstgalerie, Bochum

Ireland
Arts Council of Ireland, Dublin
Trinity College, Dublin

Israel
Museum of Tel Aviv

Italy
Peggy Guggenheim Collection, Venice

The Netherlands
Stedelijk Museum, Amsterdam
Stedelijk Van Abbe Museum, Eindhoven
Gemeente Museum, The Hague
Museum Boymans-van Beuningen,
Rotterdam

New Zealand
City of Auckland Art Gallery

Norway
Kunstnernes Hus, Oslo
National Gallery, Oslo

South Korea
National Gallery of Contemporary Art, Seoul

Switzerland
Kunsthaus, Zurich
Kunsthaus, Basel
Kunsthalle, Berne

United Kingdom
Arts Council of England
British Council
Contemporary Art Society
Calouste Gulbenkian Foundation
Peter Stuyvesante Foundation
Tate, London
McClaurin Gallery and Museum Rozelle, Ayr
Victoria and Albert Museum
Cecil Higgins Museum Bedford
Ulster Museum, Belfast
City Art Gallery, Bristol
University of Cambridge
University of Durham
University of Brighton
University of Edinburgh, Talbot Rice Gallery
Scottish National Gallery of Modern Art,
Edinburgh
Scottish Committee of the Arts Council,
Edinburgh
Royal Bank of Scotland, Edinburgh
Edinburgh College of Art
City Art Gallery, Leeds
Ferens Art Gallery, Hull
Whitworth Gallery Manchester
Fitzwilliam Gallery, Cambridge
Museum and Art Gallery, Kettering

United States
Museum of Modern Art, New York
Museum of Fine Arts, Boston
Albright-Knox Art Gallery Buffalo
Museum of Fine Arts Dallas
Institute of Art, Detroit
Wadsworth Atheneum, Hartford
Yale University Art Gallery, New Haven
Princeton University, Princeton
Art Museum, Phoenix
Carnegie institute, Pittsburgh
Museum of Art, San Francisco
Washington University Museum, Washington
Metropolitan Museum, New York

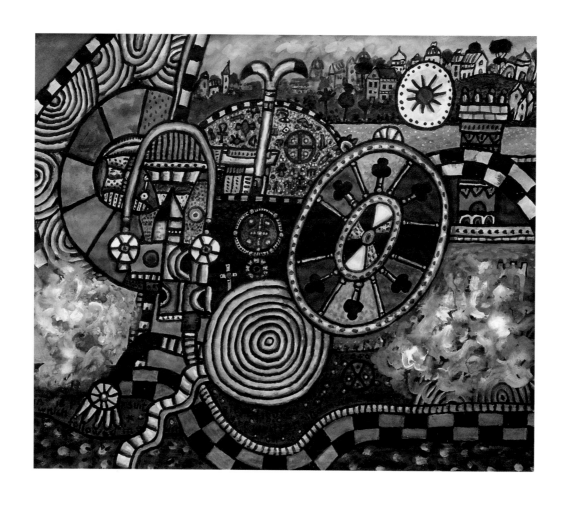

SHAMAN'S WINDOW NO.3
1999
gouache on paper
56 × 66 cm
© the artist